summer

nantucket drawings

rose gonnella

In my studio I create imaginary
interior scenes, large-scale landscapes,
and uncomplicated still lifes. In the
field I search for beautiful color
combinations and handsome forms,
recording my findings in small drawings.

In this book of color and graphite
drawings, I sought to transfer onto
paper the colors, forms, and simple
charm and elegance of a special
New England island — Nantucket.

Rose Gonnella

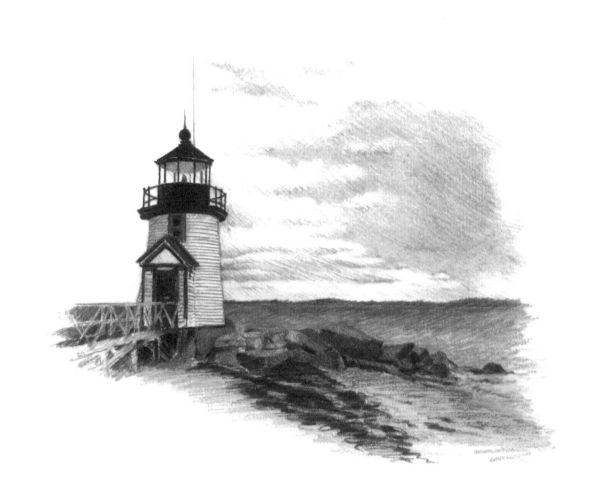

A Nantucket welcome

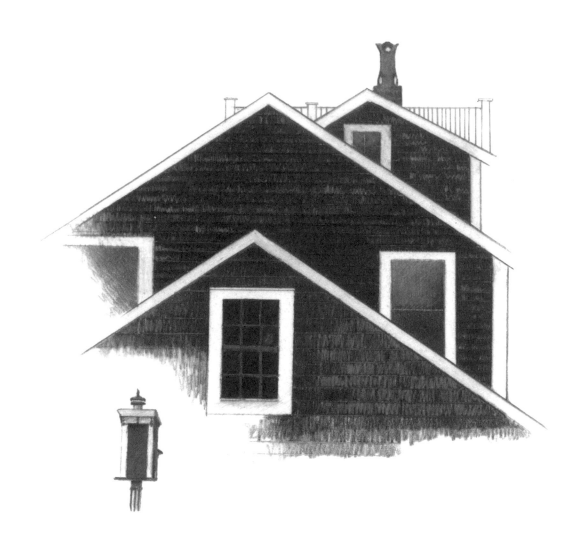

Roof walk, chimney pot, gables, and birdhouse

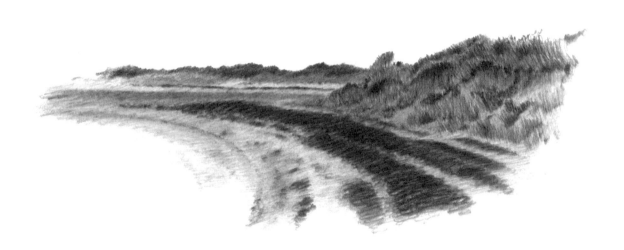

Eel grass at Pocomo

ARCHITECTURAL STYLES

1675–1700 EARLY ENGLISH
 asymmetrical, casement windows

1700–1760 LEAN-TO
 sash windows, catslide roofs

1740–1800 GAMBREL
 Dutch-influenced, steep roofs

1750–1780 LATE COLONIAL / EARLY FEDERAL
 moldings, pilasters, sidelights, entablatures

1760–1800 TYPICAL NANTUCKET
 transom lights, panel doors, equal-pitch roofs

1780–1830 FEDERAL
 symmetrical, sidelights, fanlights, entablatures

1830–1860 GREEK REVIVAL
 gable end faces street, deep entablatures, low-pitch roofs

1840–1900 ROMANTIC REVIVAL
 pointed windows, turrets, curlicues

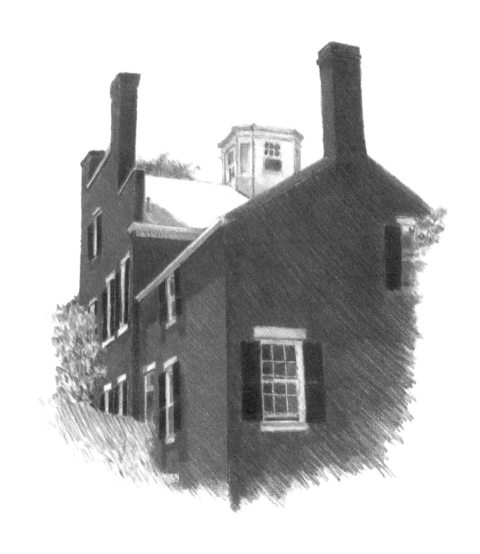

Stately brick Federal-style gables

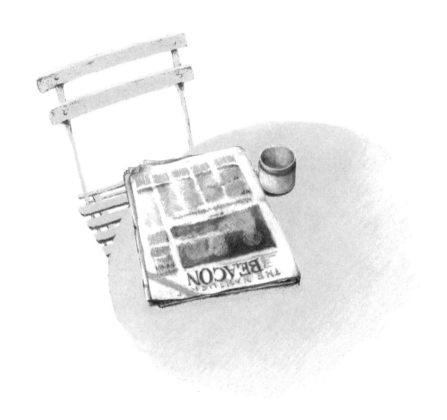

Morning news

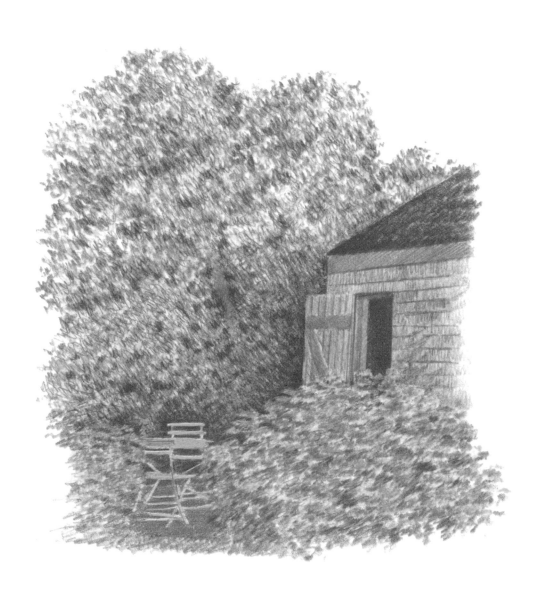

Little patio scene

1659 Tristram Coffin and a group of
 Englishmen living in Massachusetts
 buy an island 30 miles off the
 coast of the "New World."

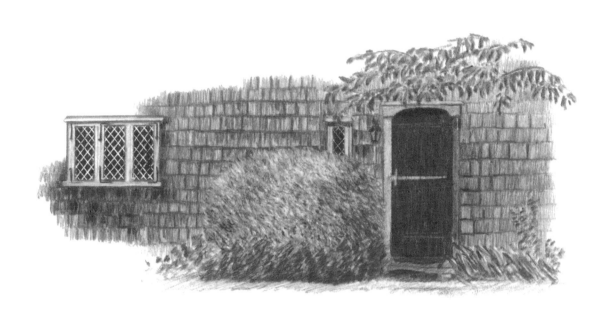

Early English cottage (casement windows, board door)

Color of hydrangeas

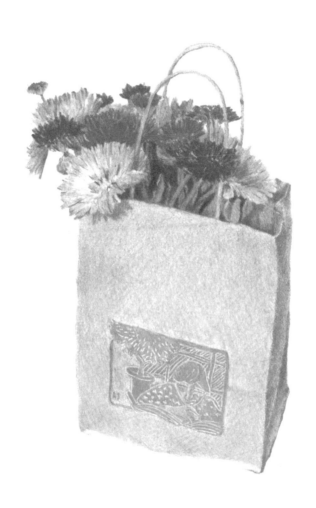

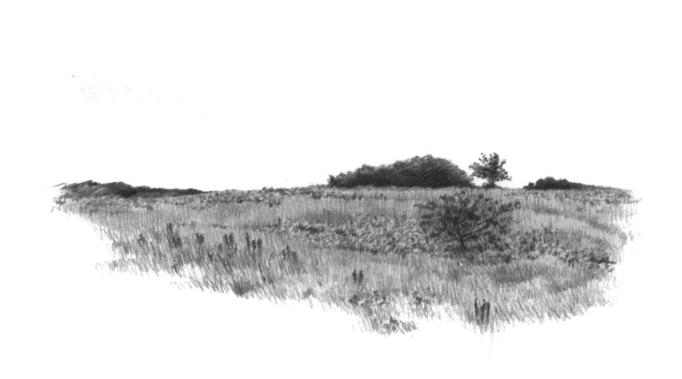

Green bush on a rise of orange grasses

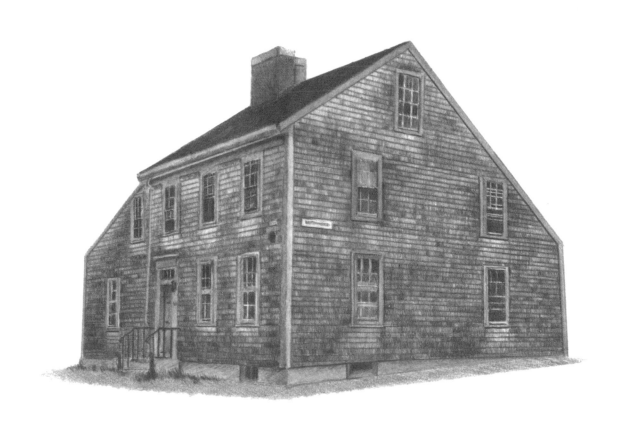

Late Colonial / Early Federal style

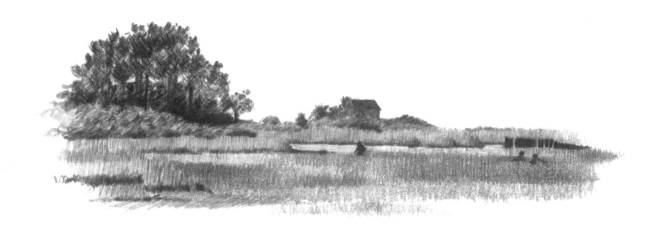

Clamming, Polpis Harbor

Broken shell on the beach

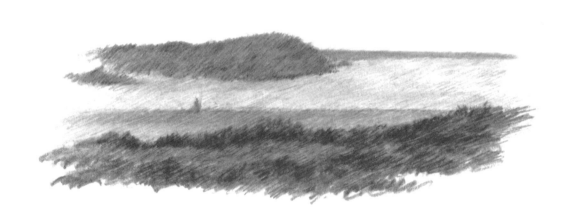

Clark's Cove, Hummock Pond — by the sea

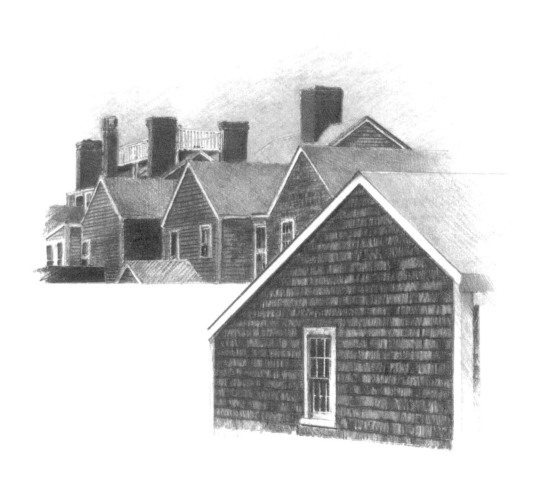

Group of gables, chimneys, and a roof walk

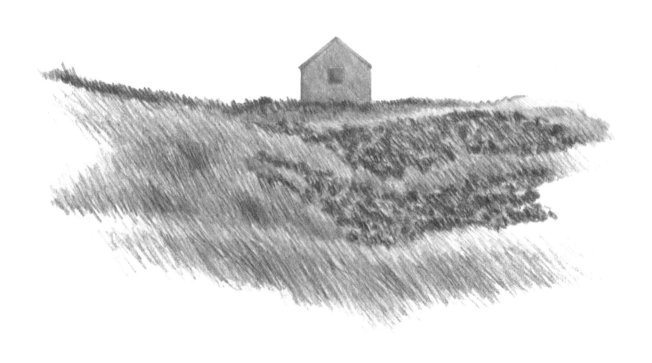

Salt-spray roses in the dunes

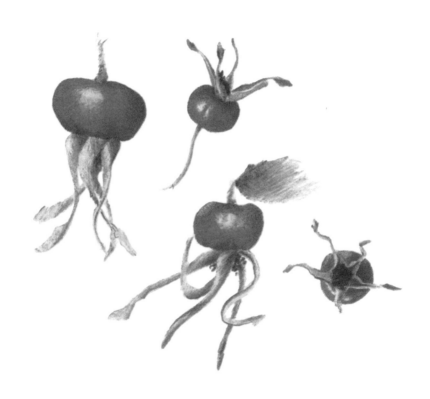

Rose hips (actual size)

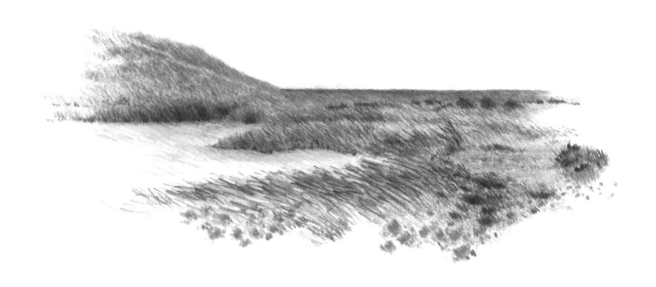

Rose mallows and grasses at Washing Pond

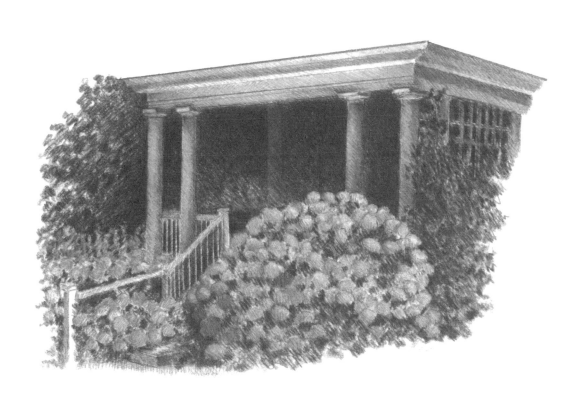

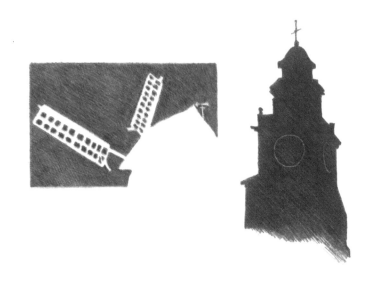

Landmark silhouettes

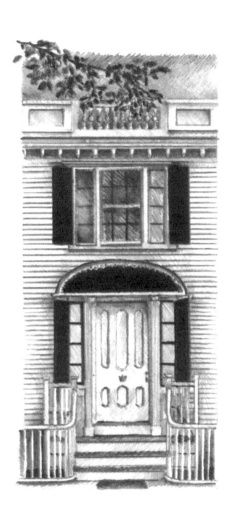

Federal-style elegance

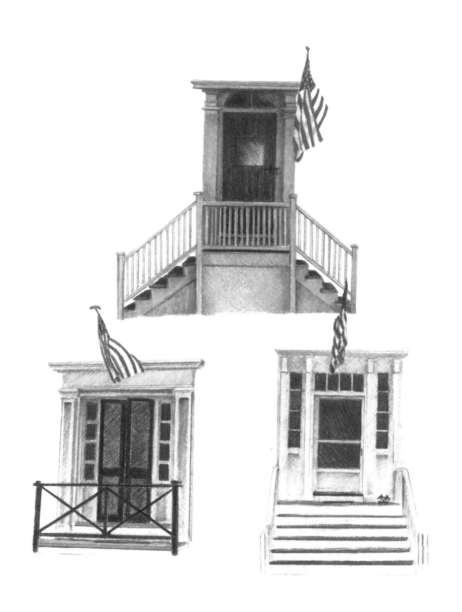

Flags flying on the Fourth

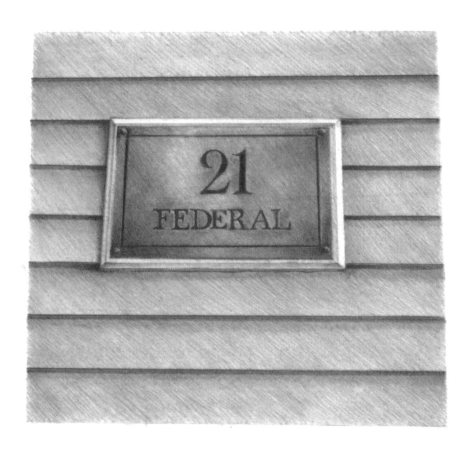

Clapboard siding at 21 Federal Street

ISLAND TIMES AND TIDES

SUNRISE:	5:29 a.m.	SUNSET:	8:04 p.m.
HIGH TIDE:	12:26 a.m.	LOW TIDES:	6:13 am.
	12:26 p.m.		6:13 p.m.

At local apparent noon today, which occurred when the Sun bore due south at 12:46:13 EDT, the Sun was 68 degrees 25 minutes above the horizon. The Sun rose and set 26.7 degrees north of east and west.

July's full moon, known as the "buck" moon, reaches its full phase at 2:25 in the afternoon. Since it rises at about 8:00 at night, it reaches its full phase before we can see it. Also it sets early Saturday morning, so it will be at its most brilliant while we are still sound asleep or should be.

REPORTED BY THE Inquirer Mirror, 25 JULY

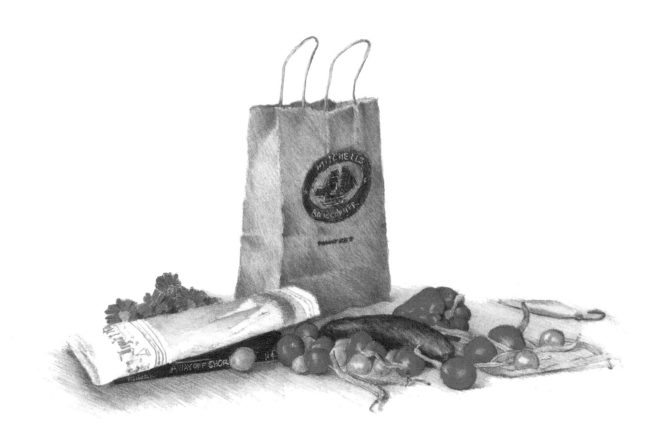

Results of a shopping spree

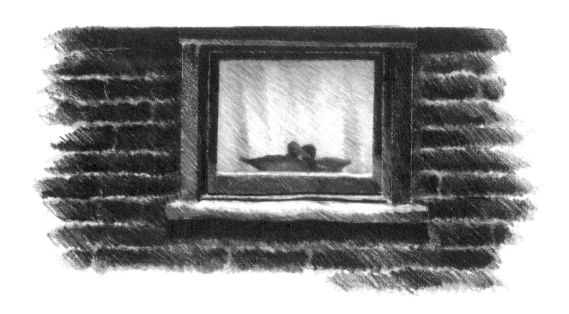

Two ducks in a window

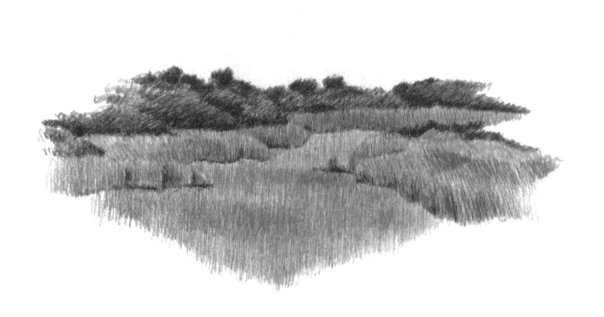

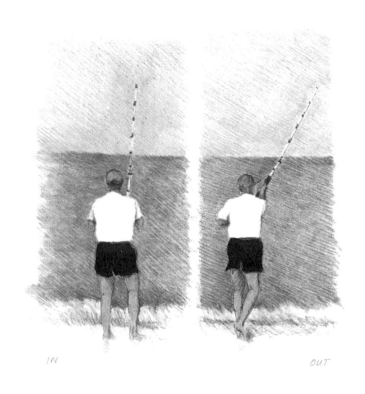

IN OUT

The ins and outs of fishing

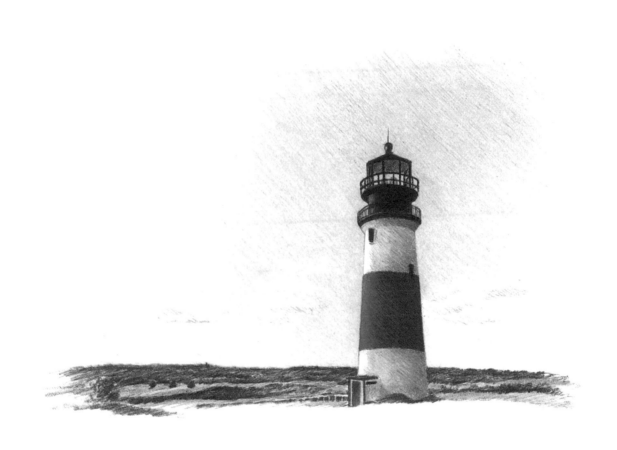

Majestic beacon on the eastern shore

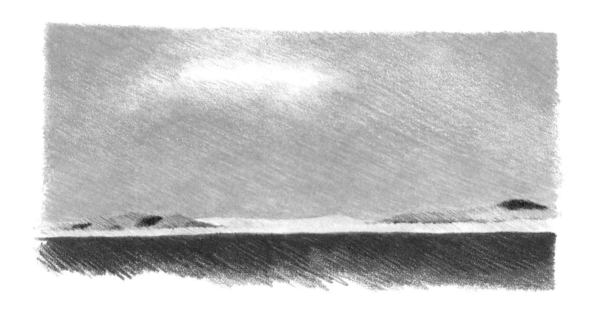

Sesachacha Pond sand bridge

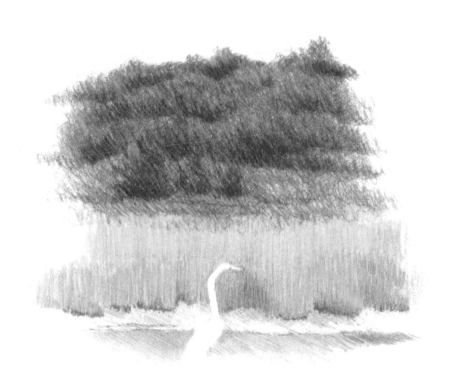

Egret

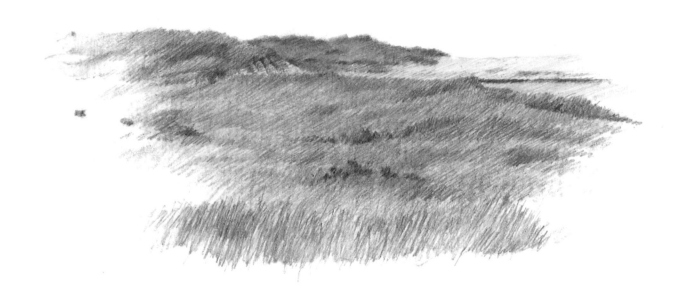

madaket dunes

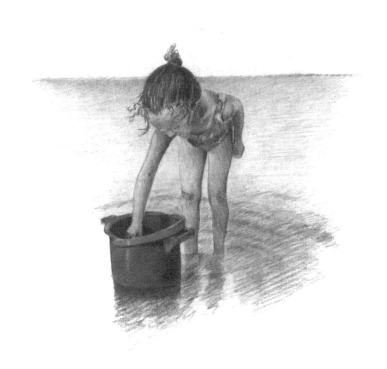

Stirring seaweed soup

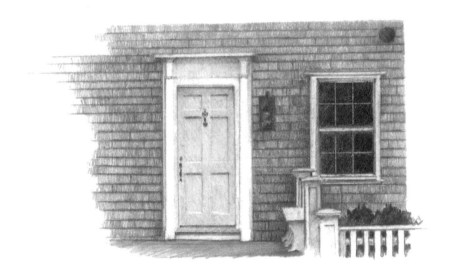

Note: ship-rail fence

1847 Maria Mitchell sights a new comet with her telescope atop the Pacific Bank building on Main Street. She becomes the first woman elected to the American Academy of Arts and Sciences.

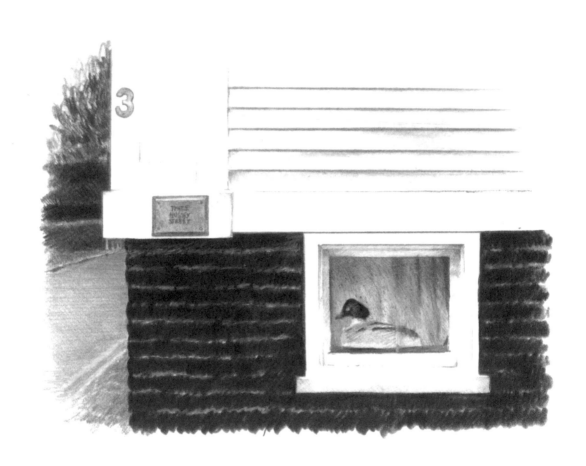

Another duck in a window

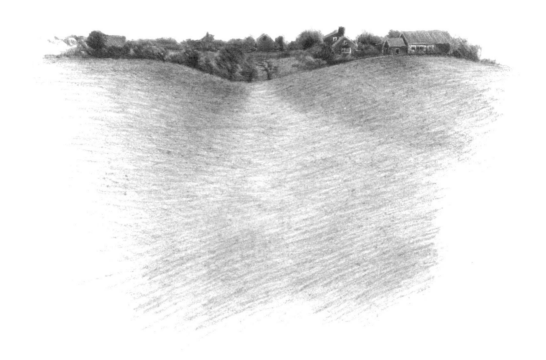

Quaker cemetery

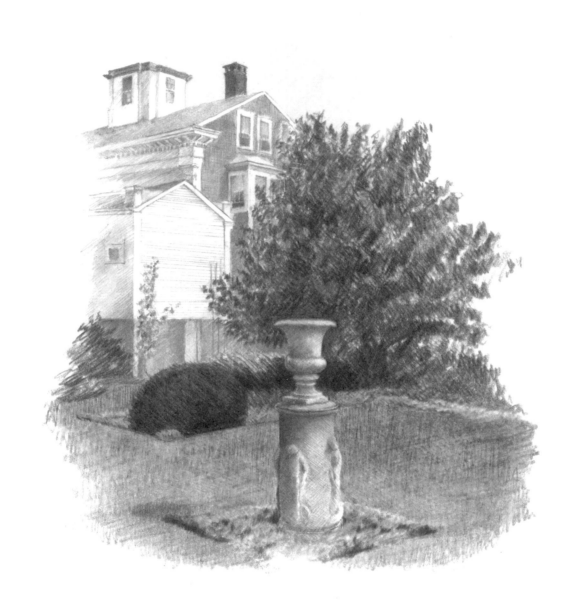

Antique garden (Hadwen House)

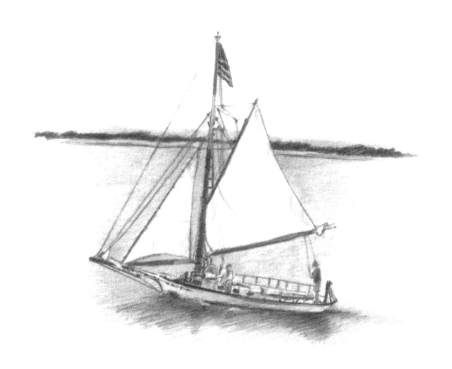

Friendly sailboat

Gambrel style in silhouette

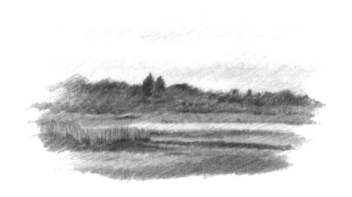

Little estuaries

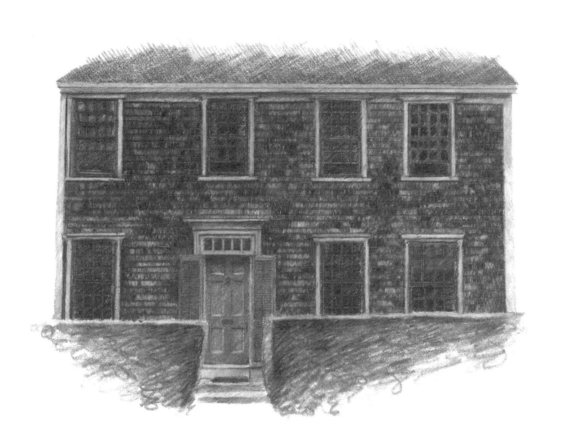

Typical Nantucket house

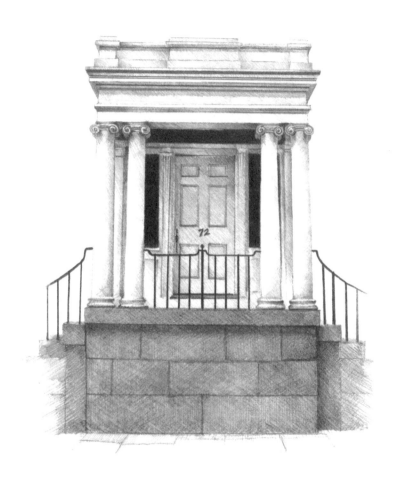

Greek Revival portico

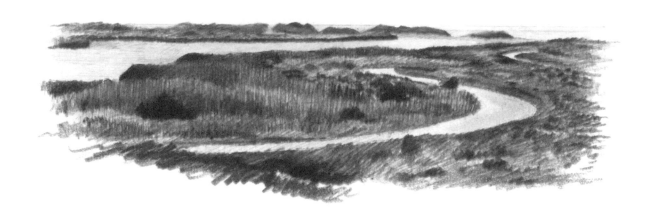

Down the road to the beach along Miacomet Pond

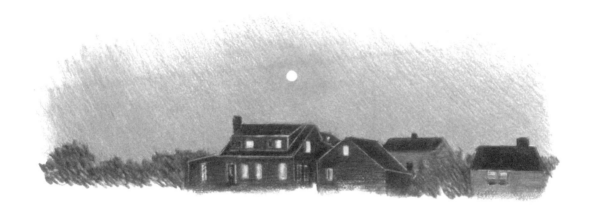

Moonrise at dusk

Little spray of early bayberries

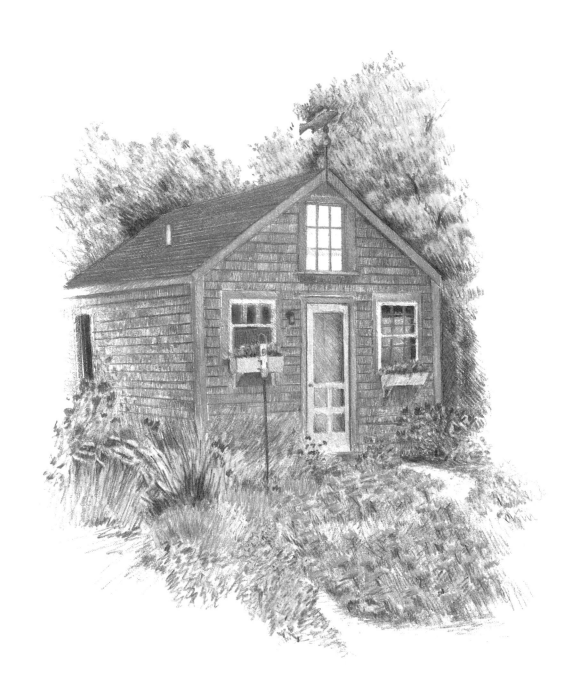

Names of houses

Hi Life
Sea-no-End
Starfish
Beachmore
Moor View
Moor Wind
Peace and Plenty
The Cobbler's House
Sea Harp
Interlude
Fine-A-Lee

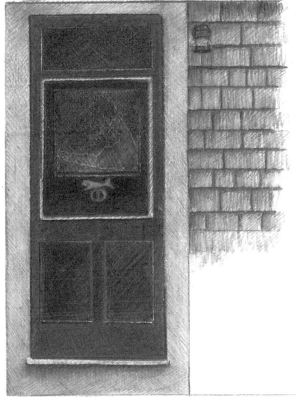

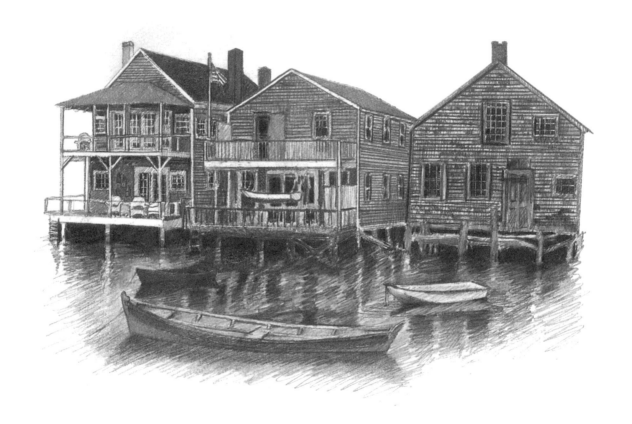

Easy Street

Across Gibbs Pond

Signs in silhouette

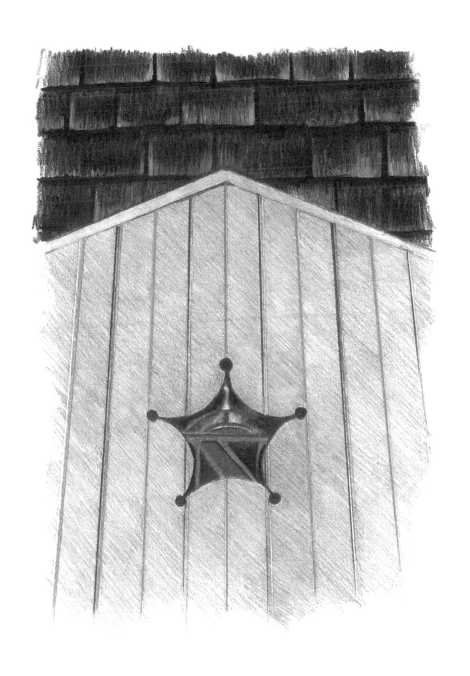

Antique window shutter (Greater Light)

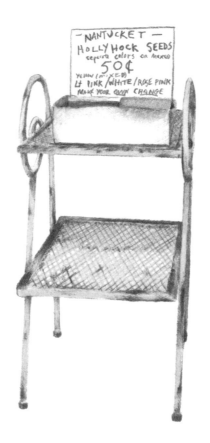

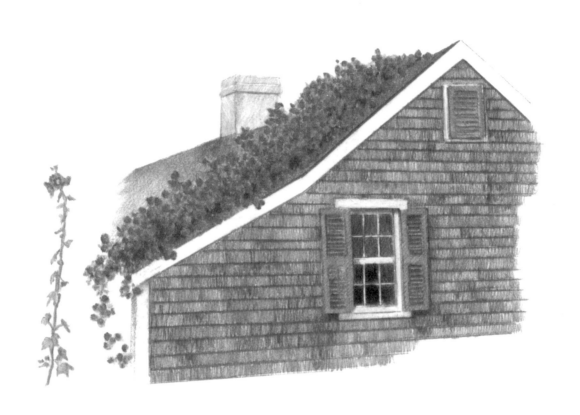

Roof roses and hollyhocks in 'Sconset

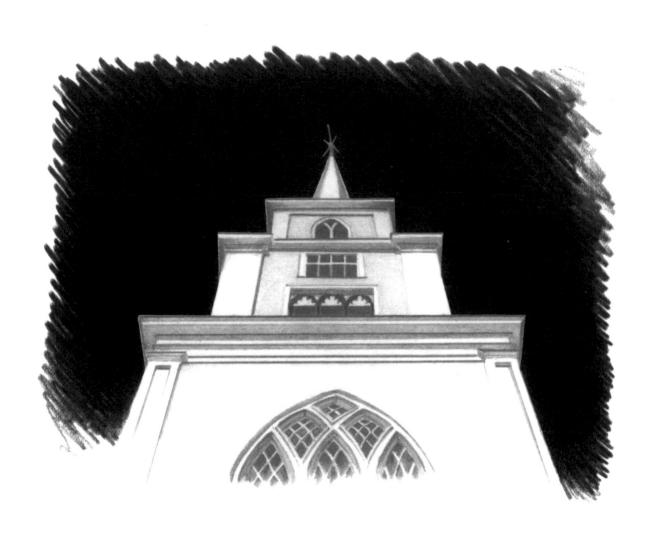

Gothic Revival style

Where to find whales:

 weather vanes
 door knockers
 tops of flagpoles
 signs
 napkins
 cards
 in the sea

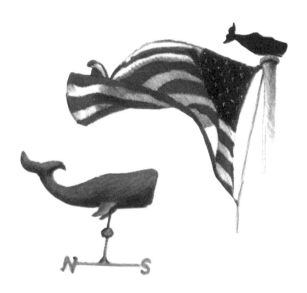

1686 Jethro Coffin marries a Gardner, uniting the two feuding families. The Coffins donate the wood and the Gardners the land to build the couple a house, now the oldest surviving house on the island.

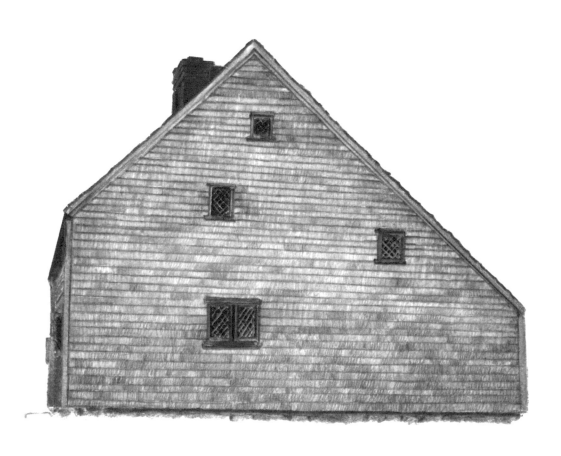

Asymmetrical beauty— Early English style

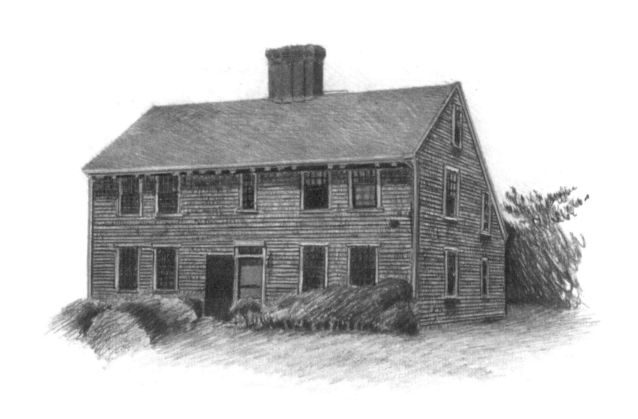

massive chimney and board door—The Lean-to style

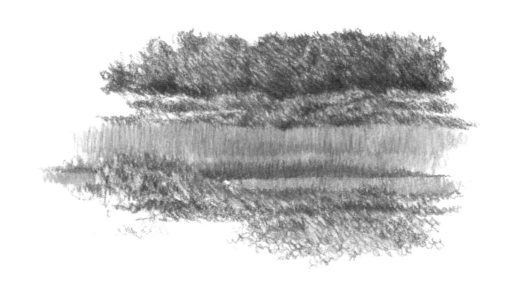

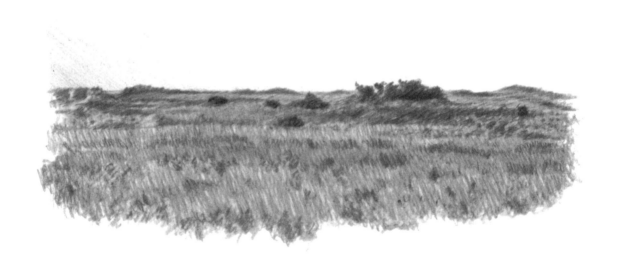

Colorful grasses before the dunes

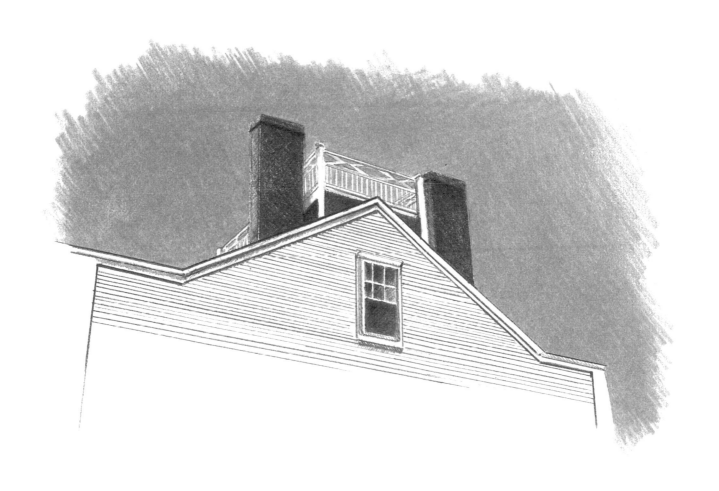

Roof walk between chimneys

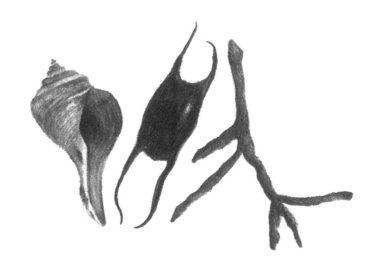

Beautiful and curious shapes on the beach

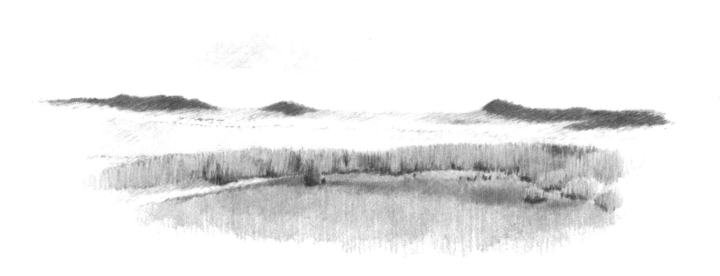

Eel Point "bathtubs"

1882 I have pleasing thoughts of the
 famous artist of the old north cliff.
 I refer to Eastman Johnson, whose
 studio stands on a breezy hill, almost
 Italian in its soft summer garniture;
 our somewhat classic cliff luminous
 with sunlight; our harbor to the right;
 the cool bath-houses along the ocean
 border; the distant fleet of snowy sails;
 all so dreamy and tremulous,—strangers
 tell us it is a poem; and so it is.
 — Dr. Jenks

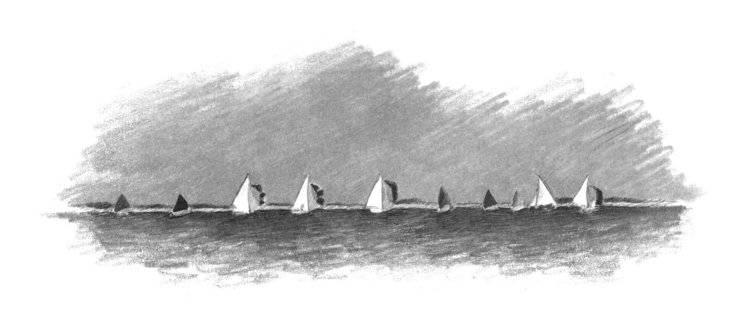

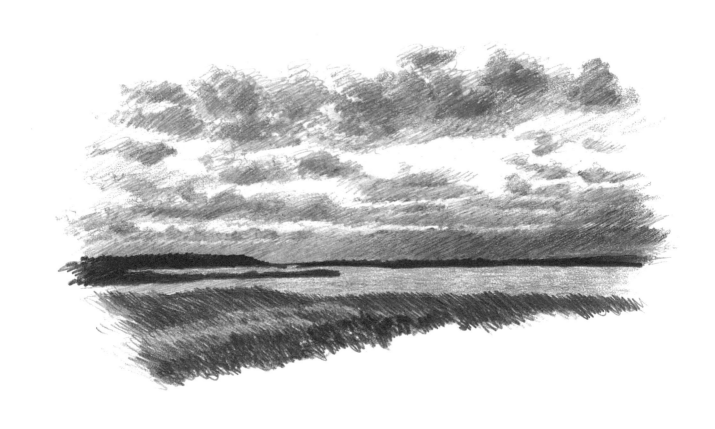

Wauwinet sunset with clouds

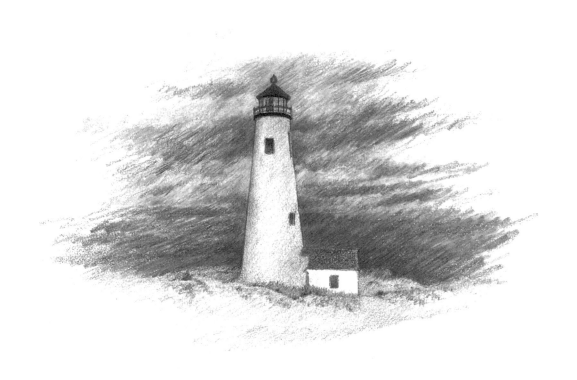

Great Point light

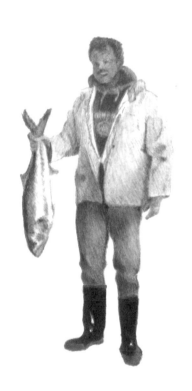

Man with his fish

Rose Gonnella has exhibited her still lifes, interiors, and landscapes both nationally and internationally for over fifteen years. Her drawings are included in the collections of the National Museum of American Art, Washington D.C.; The Museum of Art and Archaeology, Columbia, Missouri; The Sara Roby Foundation, and other public and private collections. She exhibits at the Albers Fine Art Gallery, Memphis, Tennessee; The Jane Haslem Gallery, Washington, D.C.; and The Main St. Gallery, Nantucket, Massachusetts. Ms. Gonnella is an Associate Professor of Fine Art at Kean College of New Jersey and a resident of New York State. She spends as much time as possible drawing on Nantucket.

Design: Russell Hassell
Calligraphy: Ellen Hassell
Printing: The Studley Press

Published and distrubuted by the Waterborn Group
P.O. Box 177, Palisades, NY 10964-0177